Louis Wain's Cats

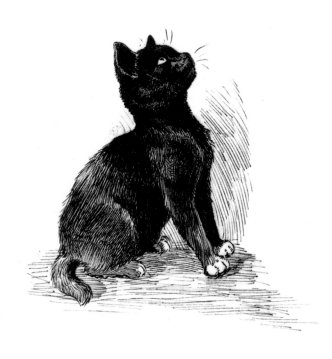

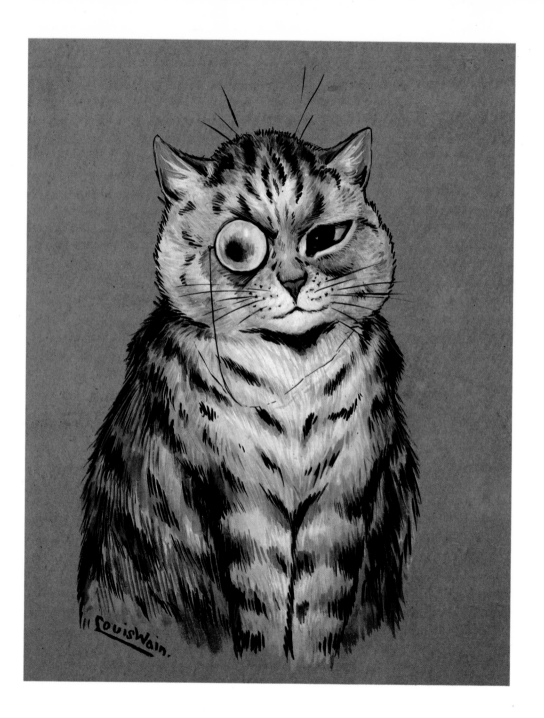

Louis Wain's Cats

Compiled and introduced by
MICHAEL PARKIN

With 62 illustrations, 32 in colour

THAMES AND HUDSON

For my four cats,
Fortnum and Mason, Sarah and Sophie

Phototypeset by Tradespools Ltd, Frome, Somerset
Printed and bound in Italy by Amilcare Pizzi Arti Grafiche

Louis Wain – 'the man who drew cats' – was an affectionate and humorous observer of the Edwardian scene. His vision of a world peopled by cats developed out of the tradition of Victorian whimsy epitomized by the art of Lewis Carroll and Edward Lear and expressed all the confidence and optimism of the age. His cats inhabit Catland, a comfortable country which closely reflects the ease, flamboyance and style of Edwardian England. Between 1884 and 1914 he illustrated countless books and annuals, and produced hundreds of picture postcards depicting cats acting as human beings in various guises: wearing top hats and monocles, playing tennis, drinking tea, making after-dinner speeches, and diverting themselves at the seaside. Louis Wain's name became a household word. As H.G. Wells said in 1925: 'English cats that do not look like Louis Wain cats are ashamed of themselves.' Yet for all his earlier fame, by the late 1930s Louis Wain was but a dimly remembered name. Fashion has caught up with him again since the early 1970s, and his postcards, books and drawings are now prized collectors' items.

Kittens, Mostly Naughty

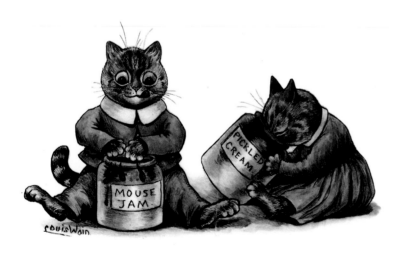

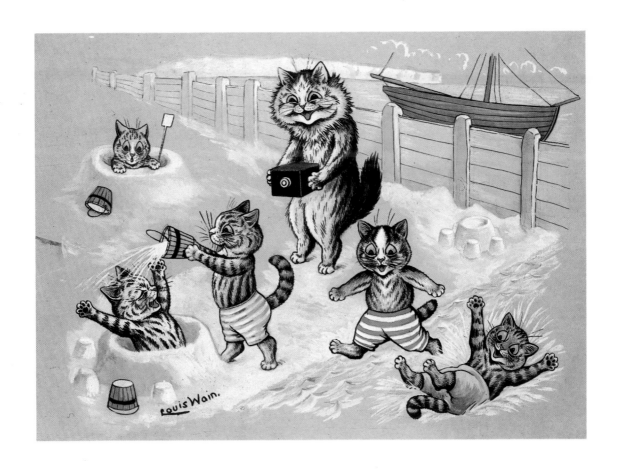

Seaside Joys on Mouseport Sands
at Shrimpton on Sea

'Oh here's the jolly season! I really think it grand
To dabble in the water and dig among the sand.'

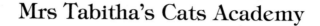

Mrs Tabitha's Cats Academy

An early work illustrated by Louis Wain, *Madame Tabby's Establishment* was published first in 1886 and then colour-printed in Bavaria four years later. As humorous prints the illustrations became very popular in Victorian and Edwardian nurseries. In this one, the centre cat of the class with his head bandaged is based on Louis Wain's own 'Peter the Great'. Kittens in the school are reading '100 Ways of Eating Mice' and 'Birds and How to Love Them', and Mrs Tabitha, complete with birch, gasps 'What are you doing there?' to two naughty kittens called Flabby and Snowball.

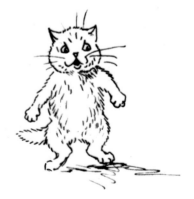

The Cats' Half Holiday
at Mrs Tabitha's Cats Academy

At Mrs Tabitha's Cats Academy the cats' half-day holiday (normally a Wednesday) on this occasion brings the conjuror with his performing mice ('as exhibited before The Chat of Persia') and the chance for the kittens to play cricket and buy fish sweets with their pocket money.

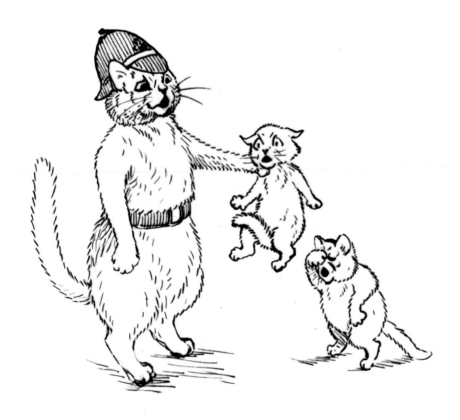

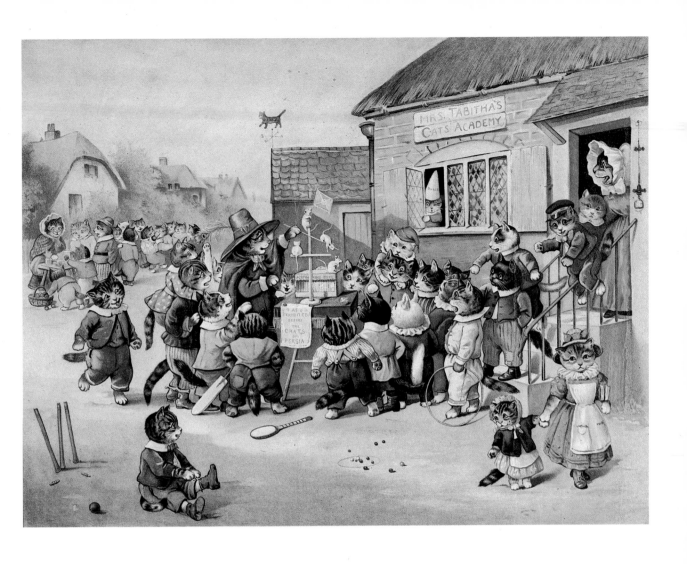

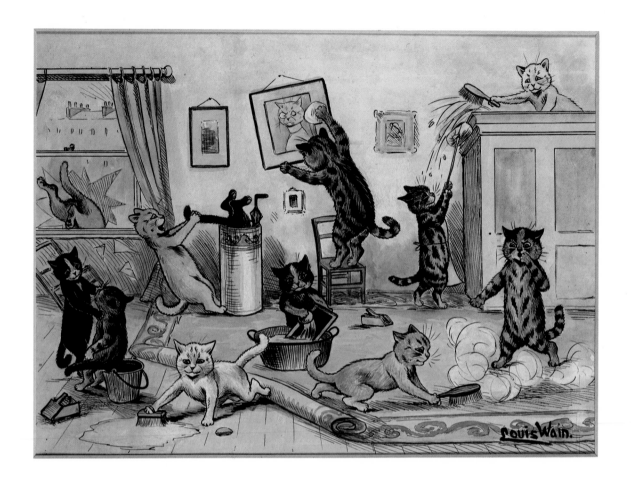

Spring Cleaning

'Look what happens when you leave the kittens alone to get on with the spring cleaning!'

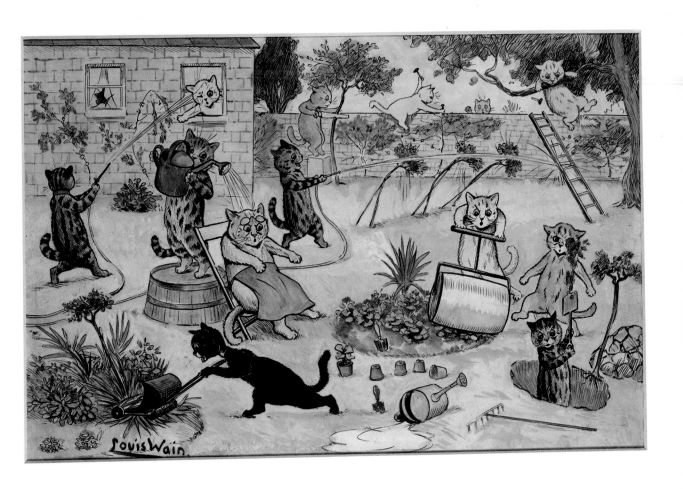

The Gardeners

'Mr Purr is going to be very cross when he returns and
finds what the kittens have done to his garden.'

The Ambush

'When Father Purr came home with the Christmas shopping, he took a short cut through the woods. Little did he know he would be ambushed by his own kittens.'

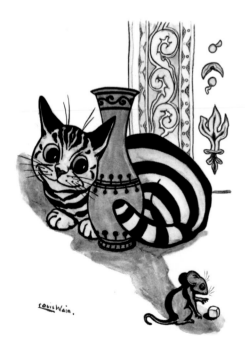

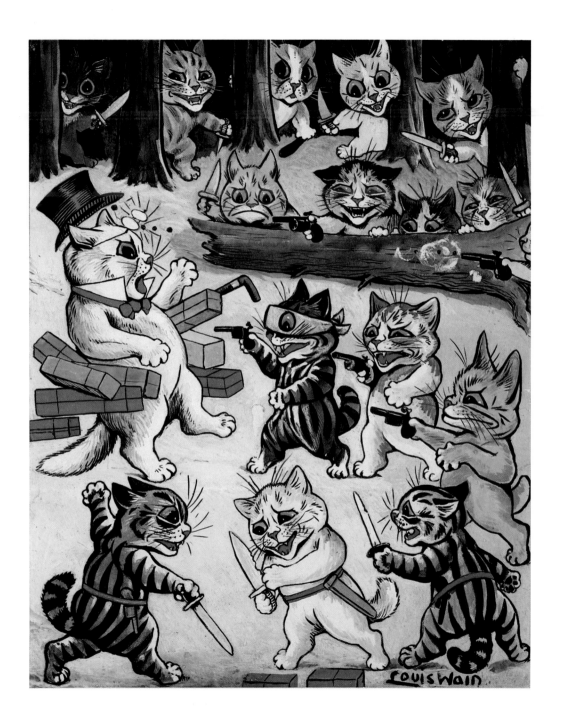

The New Arrival

'Catland, sometimes called Pussydom, is the first place we came
to ... we have just arrived at the same time as a fine Persian
pussy, who has come in a box a long way, poor thing.'

'Ho! ho! A long-haired Persian! How haughty she stares.
You won't be friends with us, Ma'am, if you put on such airs.'

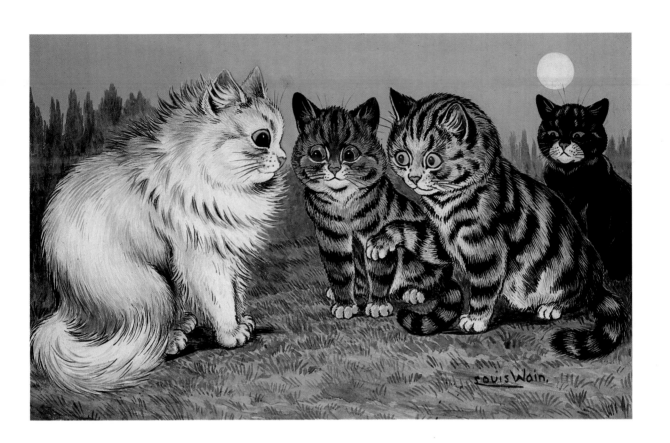

Please, Mr Persian

'Please, Mr Persian – why don't you be like us other cats and have a shave?'

High Society

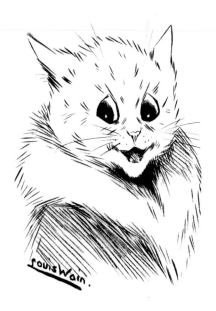

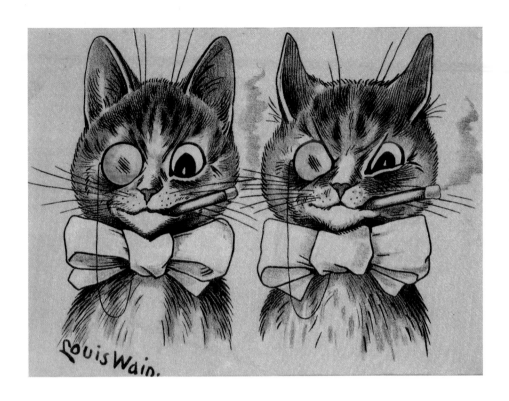

A Pair of Toff-Toms

'We cats who move in high society
Always behave with the utmost propriety.'

The Señorita of Spain

'O beautiful Señorita, will you sing to us and we will
accompany you with tambourine and castanets?'

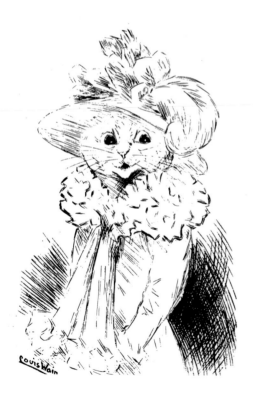

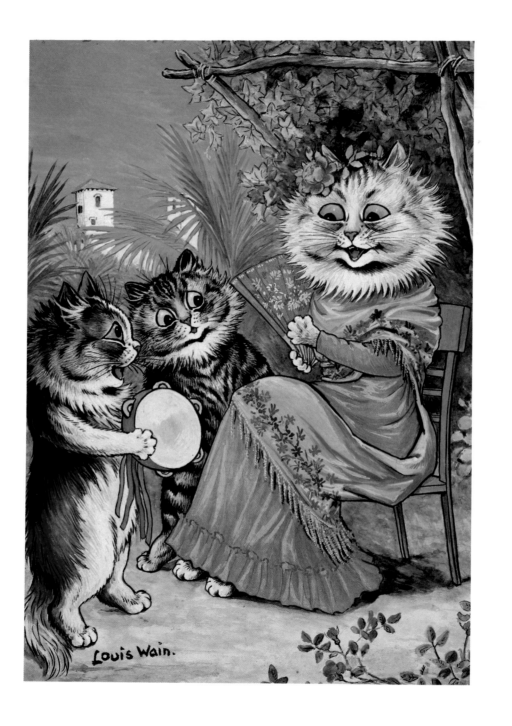

Louis Wain.

The After-Dinner Speaker

'He was a cat who always broke
Into a laugh when others spoke
And cried so if it was a joke
"That's funny, very funny!"'

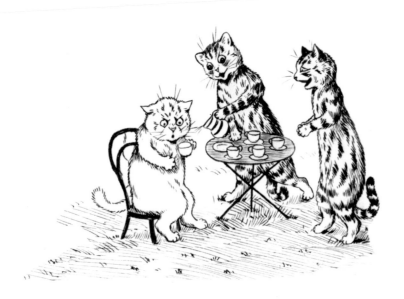

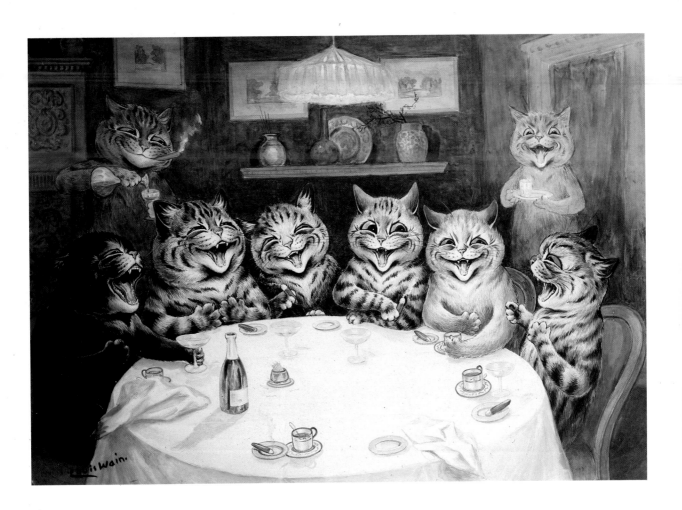

The Wedding Breakfast

'All their favourite dishes were on the table, roast sparrow, rat and rabbit pie, stuffed mice and many other dainties on which they feasted to their hearts' content. Tabby then made a speech thanking Dr and Mrs Puss for his jolly bride.'

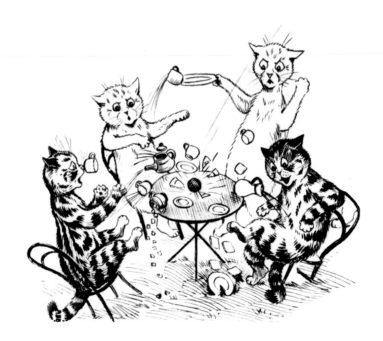

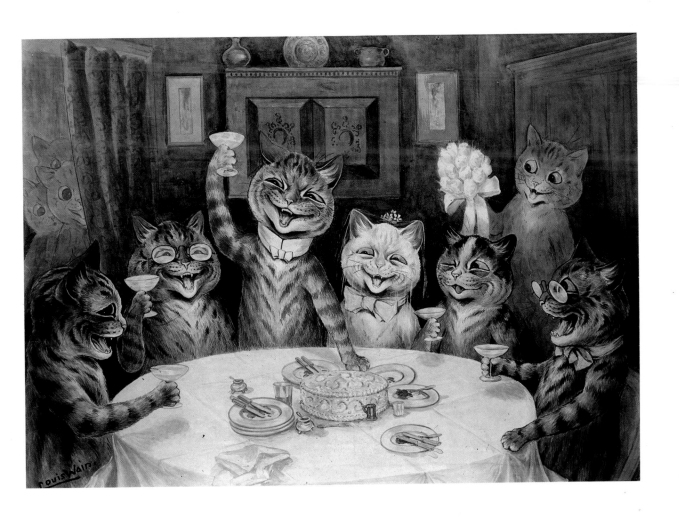

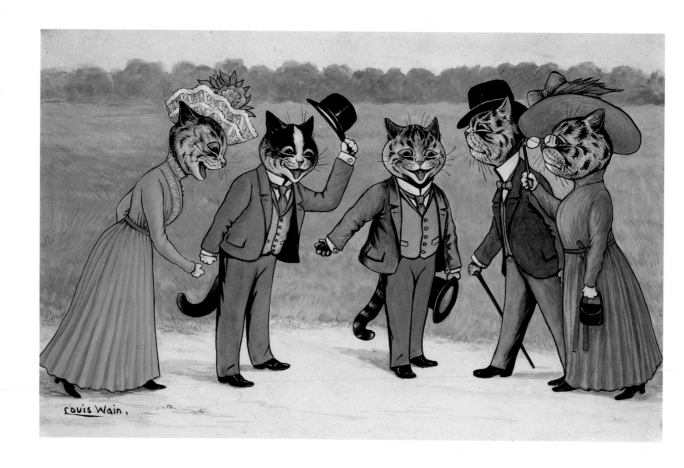

May I Introduce My Friend the Prince?

One-upmanship on the Edwardian promenade.

Afternoon Tea at Home

'Now for the tea of our host,
Now for the rollicking bun,
Now for the muffin and toast,
Now for the gay Sally Lunn!'

(W. S. Gilbert)

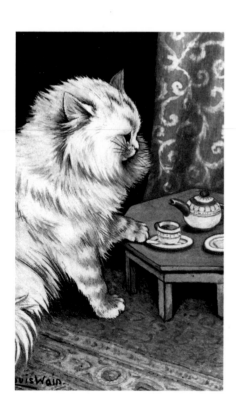

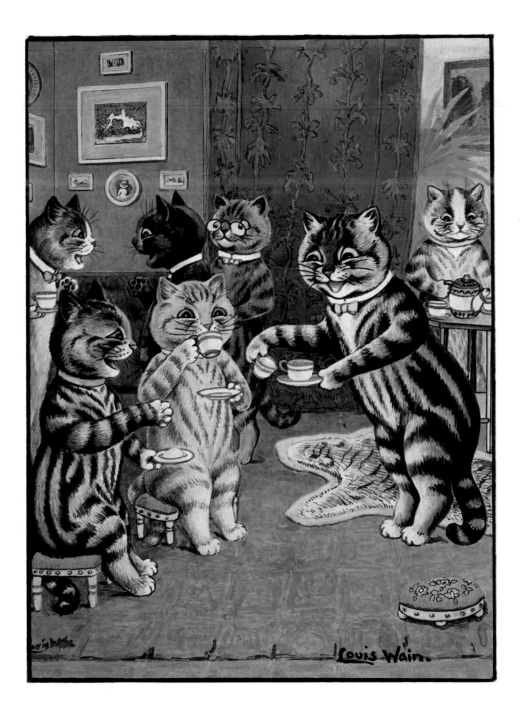

Fun and Games

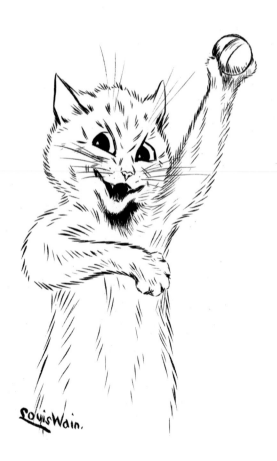

Louis Wain.

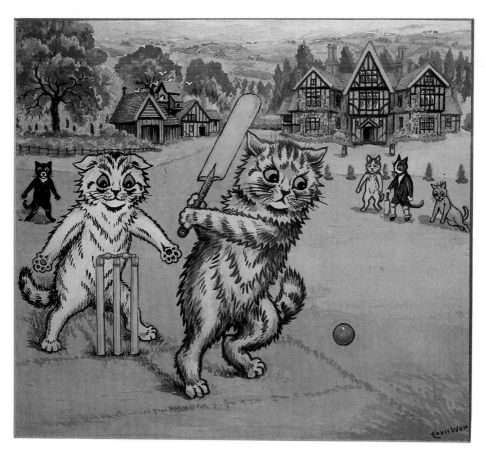

The Cricket Match, or a Dis-Grace

'He was a most conceited cat
Who thought he could play cricket.
With the first ball he was nearly out –
'Twas case of paw before wicket.

When later he missed a lovely catch
In this the great cats' cricket match,
The rest of the kittens with good cause
Shouted out loudly "Butter paws".'

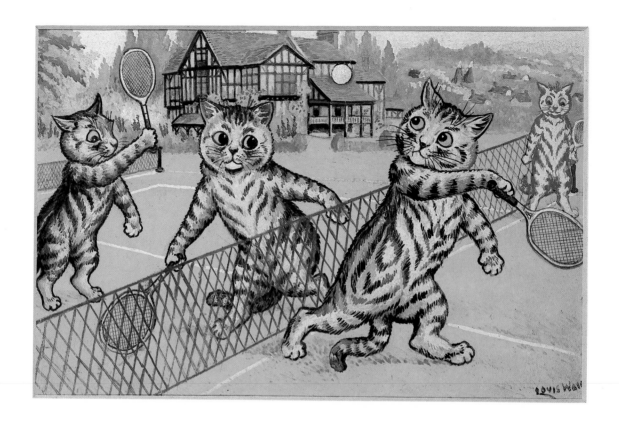

The Doubles Match

'No wonder lawn tennis is so popular.
The score "One to love",
"No love all" –
"I will try and play up to your game, Miss Pretty."'

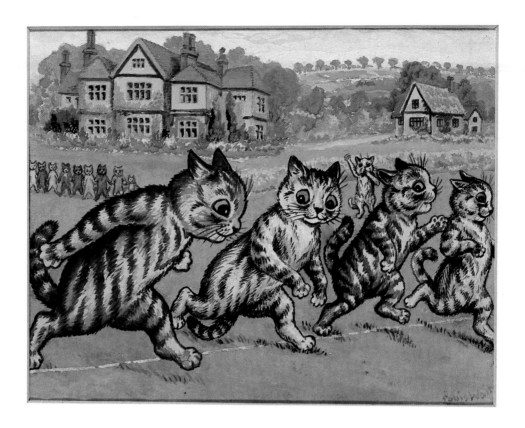

The Start of the Race

'It is the Cat-town Sports Day – they're off, and all that the kittens in the race can think of is the cream tea that follows, complete with its fish paste sandwiches and m'iced cake.'

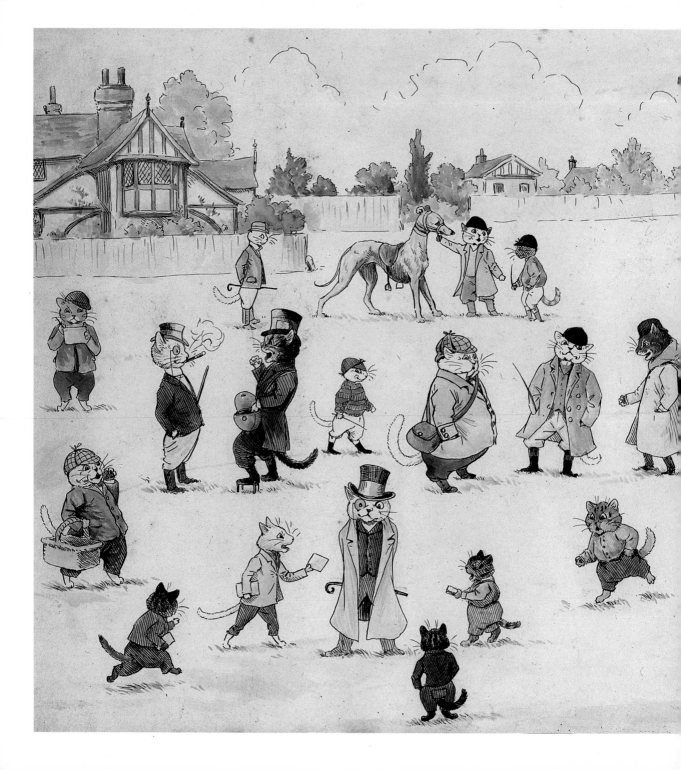

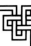

Louis Wain.

At the Cat-Town Races

At the Cat-town Races there is always
excitement because it is the dogs
that have to do the running. Everyone
in Pussdom is there including
the bookies. 'What will happen at
Cattenham Corner?' they all ask.

The Ferry Boat

'Ahoy! and Oho, and it's who for the ferry?
(The briar's in bud and the sun going down:)
And I'll row ye so quick and I'll row ye so steady,
And 'tis but a penny to Twickenham Town.'

(T.J.H. Marzials)

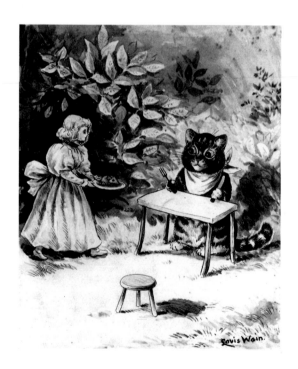

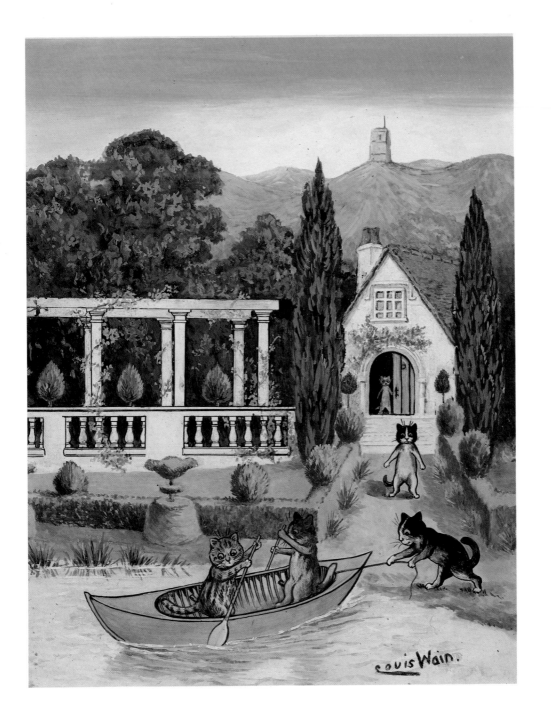

Golfing Cats

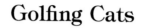

An early scene in China with the two Scottish golfers Mr McPurr
and Mr McPaw showing their new friend how to play.

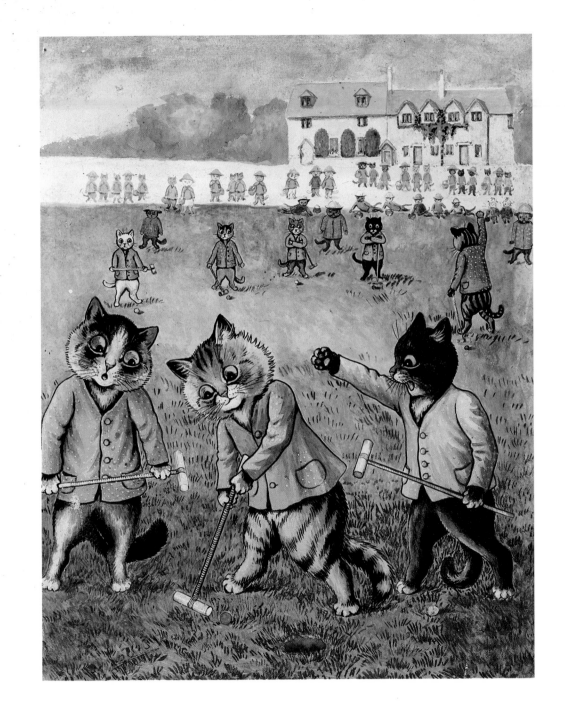

The Kittens' Ping Pong Game

'Soon cats demure and kittens small
Were learning how to "place" the ball,
And with what strength to deftly smack it
All Pusstown then was "on the racket"!

The craze spread to the nursery room –
The children there, each afternoon,
Discarding corals, bibs and rattles,
Gave bottles up for Ping Pong battles!'

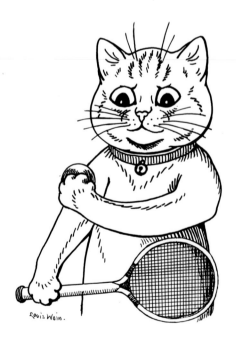

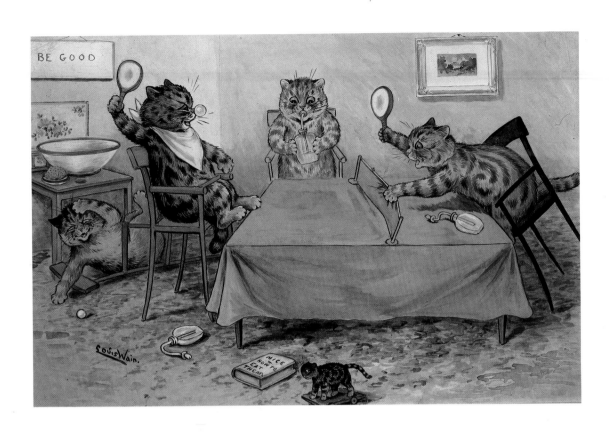

Flirts, Flowers and Friends

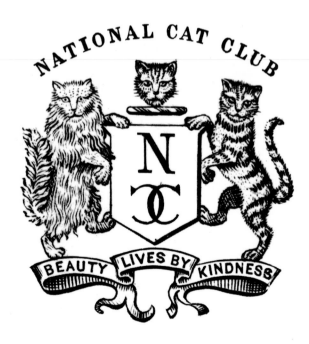

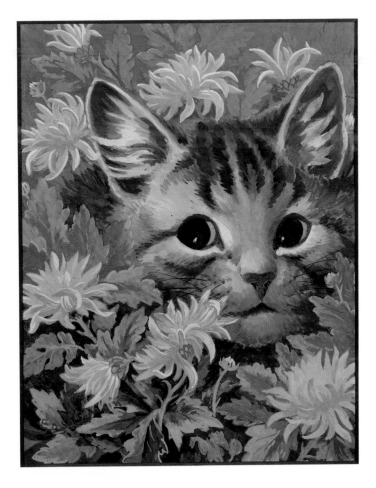

Cat in the Flowerbed

'I've bided my time for many a day
And passed by many fine cats
But the finest of all, the one I love most
Is elsewhere worrying about rats.'

The Master of Cat College

'...There's no knowledge but I know it.
I am Master of this college
What I don't know isn't knowledge.'

(Henry Beeching)

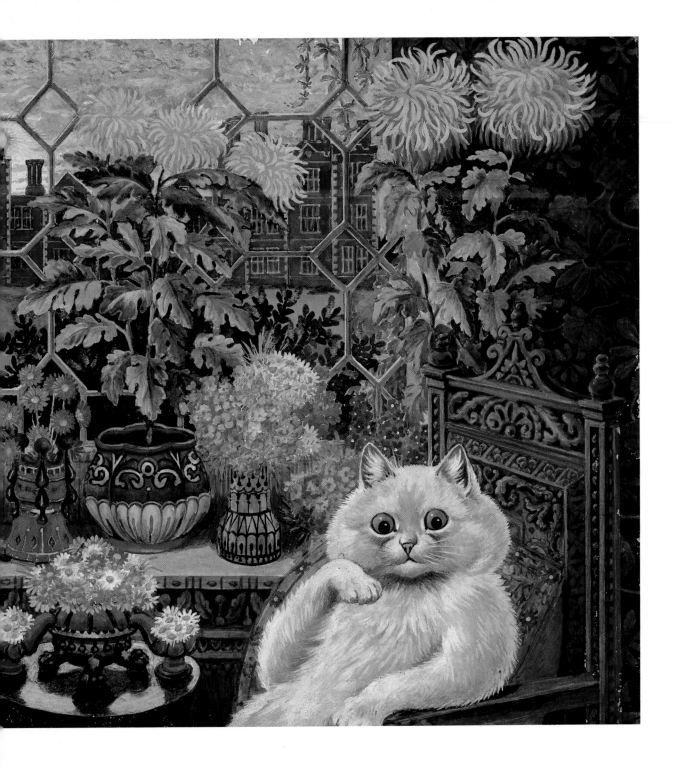

Flower Cats

'Now, my kitten, remember these proverbs: "One swallow does not make a supper" and "A mouse in the paws is worth two in the pantry."'

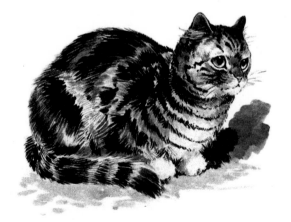

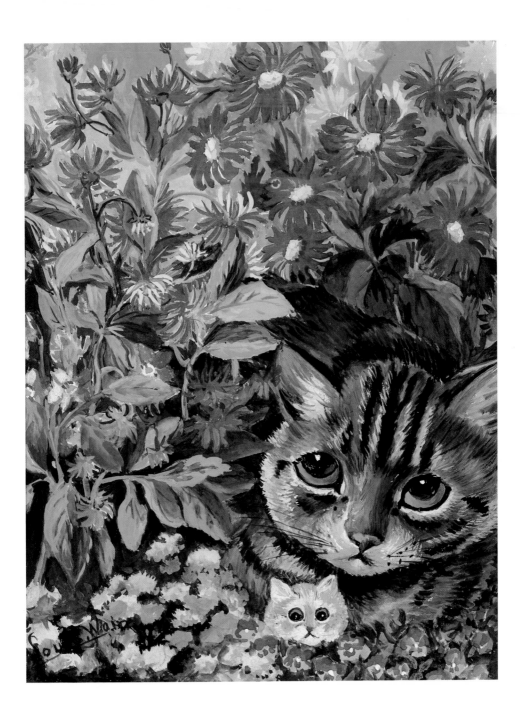

Entrenched

(A Message from Tommy (C)atkins at the Front)

A postcard from the trenches in France during the First World War, with Tommy (C)atkins sending a pointed message to would-be mother-in-laws at home that not only were soldier-cats 'Entrenched' but 'Safe from match-making maniacs – Hullo you Girls!'

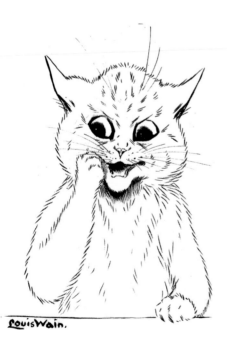

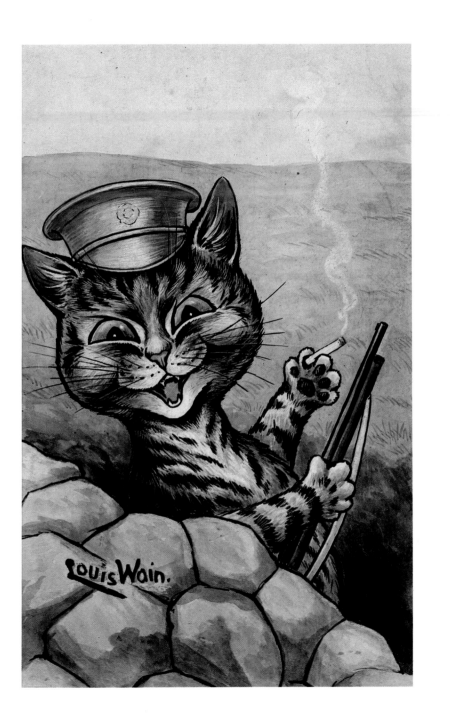

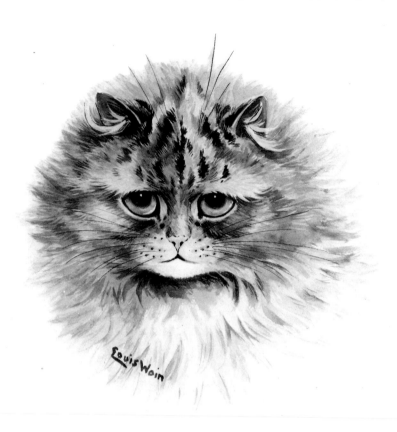

The Flirt with the Fan

'She's spick and span and very pretty
And, more than that, she's fair.
She surely knows the ways of life
That is, as much as she dare.
She knows it's wicked to twinkle her eyes
In a flirty sort of fashion,
So she opens them wide in an artless way
A prey to tender passion.'

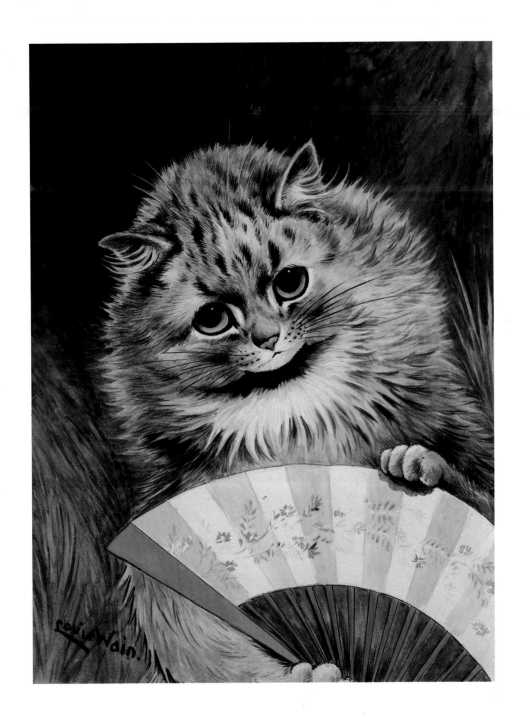

Miss Fluffy, the Grey Persian

'Poor Miss Fluffy always complains that being born on Boxing Day she is always done out of a party every year.'

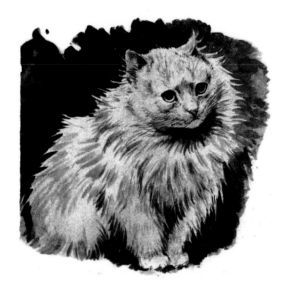

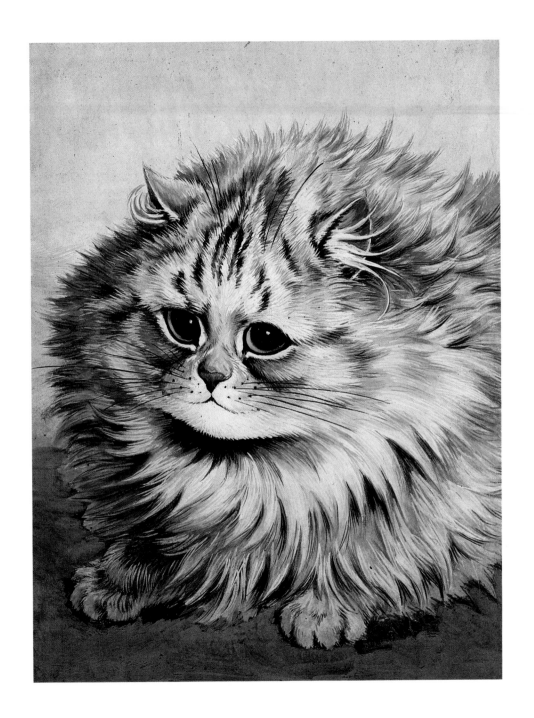

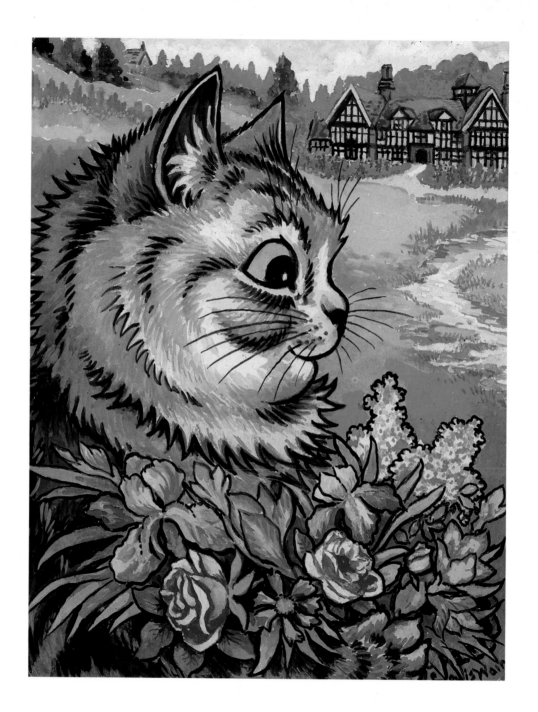

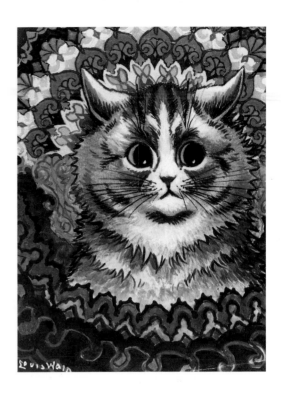

Monarch of the Garden

'I am monarch of all I survey,
My right there is none to dispute;
From the centre all round to the sea
I am lord of the fowl and the brute.'

(William Cowper)

Pirate Pussies

The Pirate Pussies left on the shore wave farewell to their ship, knowing she will return in time for next year's annual.

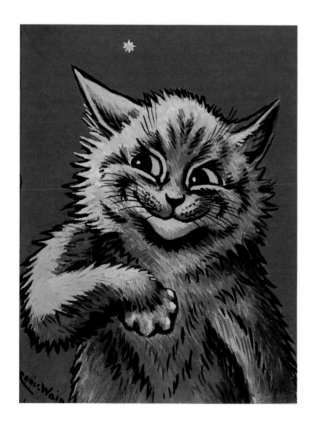

'This is the star that will show me the way home.'

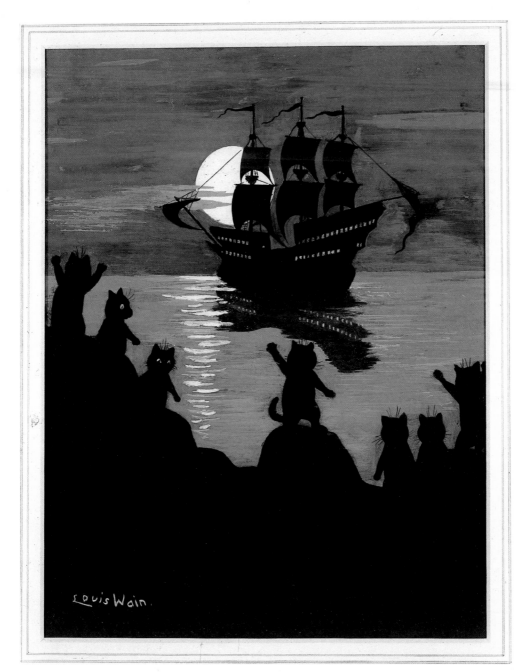

My Wallpaper

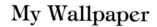

A slightly sad kitten with wallpaper drawn by Louis Wain in his last years in Bethlem or Napsbury Mental Hospital, c. 1926–36.

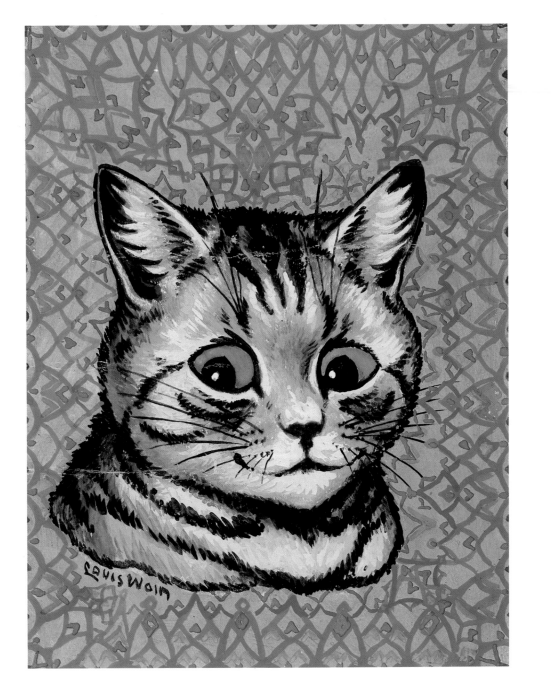

The Louis Wain Nursery Book.

Louis Wain.

JAMES CLARKE & Cº, 13 & 14, FLEET STREET, LONDON, E.C.

PRICE ONE SHILLING.

Louis Wain

Louis Wain was born in London, in St John Street, Clerkenwell, on 5 August 1860, the eldest child of William Matthew Wain, a textile traveller originally of Leek in Staffordshire. His mother, Felicia (née Boiteux), was of Anglo-French stock and had been a freelance designer of carpets and church fabrics. The Wains had six children: Louis and five younger sisters.

Louis was regarded as a physically weak child and his parents were advised not to send him to school until he was stronger. By all accounts he suffered from bad dreams and lived in a fantasy world. It was only at the age of ten that he was sent to the Orchard Street Foundation School, Hackney, in London's East End. He played truant frequently and used to wander around museums and the Thameside docks, where he never tired of going over the ships whenever he was allowed on board. In 1873 he went to St Joseph's Academy, Kennington, in south London, where he remained until 1875 or 1876, his parents paying one shilling a week. His schoolfellows regarded him as somewhat odd, an outsider who lived in his own private world. Looking back, Wain wrote in *Chums* magazine in 1895 that 'As a boy, my fancy trembled in the balance between music, painting, authorship and chemistry . . . I never contemplated being anything but an artist in one form or another.' He showed two watercolours, *The Holy Family* and *The Alhambra*, in a school exhibition and talked about writing music, even an opera. Eventually he found his true path and in 1877 went to the West London School of Art. On completing his studies there in 1880, he was offered, and accepted, the post of assistant master.

In October of that year his father died, and Louis became the chief family breadwinner. He supplemented his small income from teaching with freelance work. A drawing by Wain of bullfinches was published in the Christmas 1880 issue of the *Illustrated Sporting and Dramatic News*, mistitled 'Robin's Breakfast'. He produced a further thirty drawings before he could persuade the editor to take another one but, as he said, 'persistency told.' It in fact told so well that he was offered a staff job on the magazine in 1882. At the same time he fell in love with Emily Mary Richardson, a governess employed in the Wain household. The family did not approve of the match because Emily was ten years older than Louis. They were married at St Mary's Chapel, Hampstead, in January 1884, with no members of either family present, and went to live at 42 England's Lane, Hampstead.

Soon afterwards, as Louis Wain subsequently wrote, 'an addition was made to the household' – a newly-born black and white kitten. '"Peter", for so he was christened, came to us almost with the first sight of the world'. The cat was to be a great comfort to Emily, who had been found to have breast cancer very soon after her marriage. When she became bedridden, Peter was her constant companion. Louis would sit with his wife drawing Peter from every angle. Emily pressed him to show the drawings of Peter to his editor, but Wain still thought of himself as an artist of dogs, rabbits, fish and birds – in fact anything but cats.

In 1884 Emily's persistence paid off. Sir William Ingram, the proprietor of the *Illustrated London News*, agreed to publish the drawings of Peter. It was this black and white cat and his antics that first brought Wain public acclaim. 'He became my principal

model and pioneer of my success', Wain wrote. 'He helped me wipe out, once and for all, the contempt in which the cat had been held in this country.' The publication of his drawings in the *Illustrated London News*, together with a book entitled *Madame Tabby's Establishment*, brought the fame Emily wanted for her husband.

It is interesting to note that in Britain the idea of the cat as a pet was fairly novel. 'When I was young,' Wain declared in 1895, 'no public man would have dared acknowledge himself a cat enthusiast – the man who would take an interest in the cat movement was looked upon as effeminate – now even M.P.s can do so without danger of being laughed at.'

Wain's pleasure in his new-found fame was short-lived. Emily, who had been in great pain, died in January 1887, after only three years of marriage. The young widower was greatly affected by his wife's death and withdrew more and more into himself. In the spring of 1887 he moved to lodgings in New Cavendish Street accompanied by his one intimate friend, 'Peter the Great'. There he turned his energies to satisfying the mounting demand for his work.

Although he produced many drawings in 1888 and 1889 for Sir William Ingram's *Illustrated London News*, the true Louis Wain cat did not materialize until the Christmas issue of 1890, when the *Cats' Christmas Dance* and *A Cat's Party* were published. The transition to humanized figures had begun. Elegant cats in evening dress, sporting monocles and cigars, stand and dance on their hind legs. The British public loved them and Louis Wain soon became a household name.

The artists who influenced his development were Randolph Caldecott and such illustrators for *Punch, Graphic* and the

Illustrated London News as Harry Furniss, Linley Sambourne, Caton Woodville, Alfred Praga and Phil May. They frequently met in Fleet Street bars, and their friendship led to regular Sunday musical evenings at Praga and May's Kensington studios. Phil May's combination of serious observation and caricature of humankind was adapted by Wain to depict the activities of the inhabitants of 'Catland'.

Alongside Louis Wain 'The Hogarth of Cat Life' (as the editor of *Punch* had called him) was Louis Wain the cat expert. In 1890 he was made President of the National Cat Club. He devised the club's coat of arms and its motto: 'Beauty Lives by Kindness'. A fluent and commanding chairman of meetings, he declared that he would like 'to bring all the different catty interests in harmony.' Breeding had begun to produce more exotic, pure and stronger cats, and under Wain's presidency the first known cat stud book was produced.

Acclaimed as an authority on cats, the public listened to what he had to say. What he had to say, however, included some distinctly strange ideas and novel theories, some of a quasi-scientific nature. According to Louis, the frailty of the cat's brain causes it to dislike change, so that when separated from its original home it often returns over incredible distances. The cat, he suggested, has its own compass that works through the electrical strength of its fur being attracted by either the negative or positive poles of the earth, thus pointing it in one direction or another. A cat washes not only to clean itself, but, according to Wain, 'to complete an electrical circuit, for by so doing it generates heat and therefore a pleasing sensation in its fur.'

'Intelligence in the cat is underrated' he told an audience, pointing out that although the cat was regarded as sacred in

Egypt and Siam, it was now up to modern man to undertake its training. Once the animal had been trained for three or four generations it showed its development, he said, in 'manners, intelligence and facial expression'.

Some of his theories were not as strange as they seemed. In an interview for *The Idler* in 1896 he said: 'I have myself found, the result of many years enquiry and study, that all people who keep cats ... do not suffer from those petty ailments which all flesh is heir to, viz. nervous complaints of a minor sort. Hysteria and rheumatism, too, are unknown, and all lovers of "pussy" are of the sweetest temperament.' Nearly a hundred years later, in 1983, Professor Isaacs of Birmingham University embarked on a large-scale research project to investigate the theory that old people on their own live longer and are healthier if they keep a cat.

His mother and sisters, estranged from Louis since his marriage, were aware of his growing fame and conveniently concluded that living a solitary life could not be right for him. Sir William Ingram brought about a reconciliation, and suggested that they all settle in Westgate-on-Sea, where he himself owned a great deal of property. Reunited, the Wains moved to 16 Adrian Square in this quiet seaside resort, where Louis could at last enjoy recreations like fishing, swimming and boating. He also had a keen interest in boxing, and it was this that made him name both their next two houses 'Bendigo Lodge' after the prize fighter William Thompson (1811–1880), nicknamed 'Bendigo'.

In 1895 they moved to the first Bendigo Lodge, a large corner house at 7 Collingwood Terrace, later moving to a smaller establishment at number 16. The Wain family liked the change from London to Westgate and were to live there for twenty years.

Mrs Wain worked at embroidery and hangings for the Catholic church. His sisters Claire and Felicie painted and sketched. But the important person in their eyes was now Louis. Despite their modest financial resources, they were happy and they managed.

The inhabitants of Westgate must have found Wain rather odd at times. He regularly attended informal Westgate Tennis Club dances dressed in a white tie and tails. The fact that he was unable to dance did not stop him giving solo performances. Many of his letters to the papers proffered novel theories that often confused minor and major issues and made him seem something of a crank. Nevertheless, the burghers of Westgate regarded his oddness as harmless eccentricity. They recognized his talent and on one occasion paid him a suitably whimsical tribute. Offered a drink at a party, he turned down tea or alcohol but, when pressed, said he would have some milk. It was served in a saucer.

Less harmless was Louis' youngest sister, Marie, who suffered from the delusion that she had leprosy and that her teeth were falling out. Consequently, she would let no one come near her. In 1900, at the age of 29, she was sent to a private mental home. A year later Marie was certified insane and admitted to a hospital near Canterbury, where she died in 1913.

The first of the Louis Wain annuals, published by Treherne, appeared in 1901. Illustrated throughout by Louis Wain, they contained short stories of wit and wisdom by various contributors. The annuals were so successful that they continued almost without a break until 1913. The year 1902 saw the start of his association with the well-known publisher Raphael Tuck, who brought out books and postcards by the artist. At a time when the telephone was still a rarity, postcards provided a fast

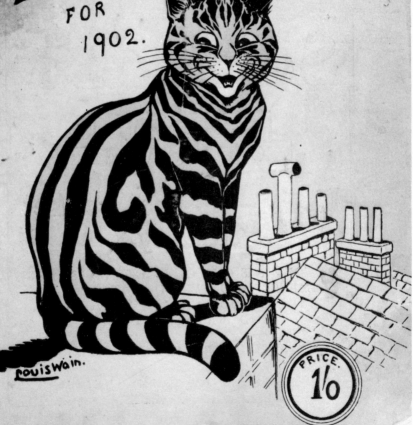

LOUISWAIN'S ANNUAL

FOR 1902.

PRICE. 1/0

A. TREHERNE & Co., Ltd., 3, AGAR ST., LONDON, W

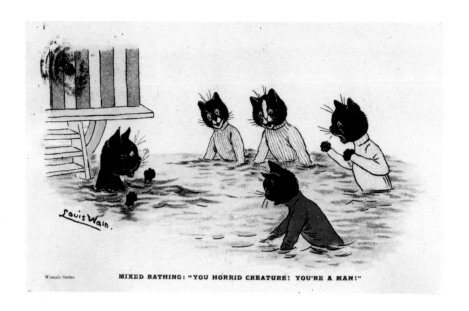

MIXED BATHING: "YOU HORRID CREATURE! YOU'RE A MAN!"

and convenient method of communication, delivered a few hours after posting, and they were avidly collected as keepsakes.

As his fame grew, more and more firms approached Wain to illustrate books, articles and picture postcards with his humanized cats. The public adored his drawings, and his popularity was so great that it was said that 'Christmas without one of Louis' clever-catty pictures would be like a Christmas pudding without currants.'

Wain should have been a rich man, but his shyness, combined with a dislike of bargaining and a failure to retain any reproduction rights for his work, meant that he received only a fraction of what could have been due to him. Eventually, commissions dwindled. There were so many Wain drawings in circulation that old ones were used again and again to illustrate new stories, and picture postcards were published with no fee

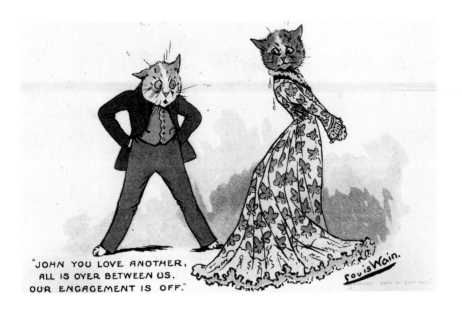

"JOHN YOU LOVE ANOTHER,
ALL IS OVER BETWEEN US,
OUR ENGAGEMENT IS OFF."

being paid to him. There were even forgeries signed 'Louis Wain'. He considered litigation, but could not afford it. At the same time he was sued for debt in the Kent County Court and lost the case. Fortunately, just at this moment, an invitation came to appear as a guest speaker at the Beresford Cat Show in Chicago.

On 12 October 1907, Wain sailed for New York. Almost immediately after his arrival, 'the world's most famous cat artist' was offered a contract to draw a cat strip cartoon for the *New York American*, one of William Randolph Hearst's newspapers. He was genuinely surprised by the welcome and the number of invitations he received from the American Cat Fancy and their clubs. Newspapers quoted his remarks, like 'puss is less vain than woman' and 'little animals are the friends of man'. He made, and even saved, some money while in America, until he met the

inventor of a new 'near everlasting lamp'. Wain invested in it, with the result that he lost everything he had managed to put away.

Early in January 1910, he received news from his sisters that his mother was ill, and returned to England only to find that she had died while he was at sea. It was a difficult homecoming, for he had come back as impecunious as he had left. Six months later, however, the Japanese Exhibition opened in London, and Raphael Tuck had Wain drawing cats with slant eyes and brightly coloured kimonos. Between 1910 and the beginning of 1914 he worked hard to provide for himself and his sisters by producing illustrations for any publisher that showed interest. Annuals and other volumes were published by Raphael Tuck, Routledge, Clark, Blackie, Shaw and others.

With the war, Louis Wain found himself still famous, yet with a decreasing income. He had no royalties, as he invariably sold his work for an outright fee, and the wartime paper shortage meant that there were very few commissions. Following his mother's death he had sole responsibility for the family. This caused him keen anxiety and may well have been a contributory factor to his falling from the platform of a bus in 1914. He was taken to St Bartholomew's Hospital suffering from concussion. Reporting the accident, journalists inevitably produced a cat which had supposedly caused the bus to swerve and brake. They also put words into his mouth: on regaining consciousness Wain was said to have asked, 'Is the cat all right?' After two or three weeks recovering, during which time he talked with Queen Alexandra when she visited the hospital, he was allowed to return home to Westgate-on-Sea. But he said he was disturbed by the thought of German bombs falling on the town and its nearness to Germany,

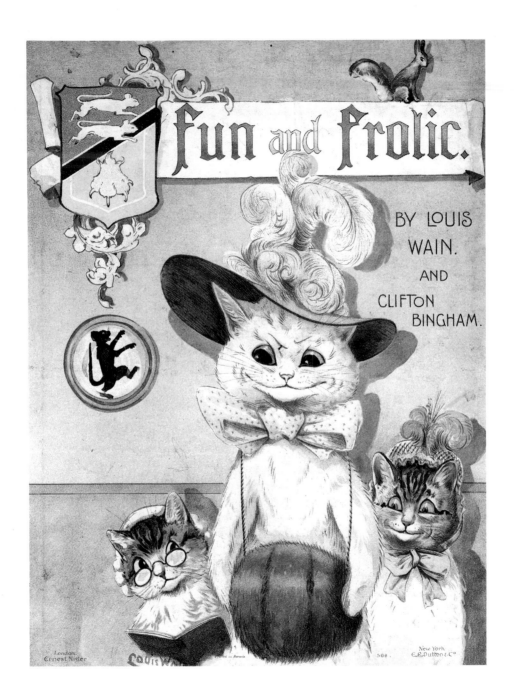

so it was decided that the family would move back to London. In September 1916, the Wains settled in a somewhat modest house at 41 Brondesbury Road, Kilburn, in north London.

The new home brought new tradesmen – and new debts. Little work was coming his way, and this often meant that the local shopkeepers had to be satisfied with a drawing in lieu of cash. Although Wain illustrated four annuals in 1916 and 1917, as well as a series of postcards featuring Tommy (C)atkins, he turned his attention to other areas in order to earn a living. He sought advertising work and designed posters, including some for teas made by Jacksons of Piccadilly, which showed his cats enjoying endless tea parties and picnics. Designing posters for the cinema led him to meet H.D. Wood, the pioneer film maker, who invited him to try his hand at film animation at Shepperton. Although normally a rapid worker, Louis found providing sixteen separate drawings for each second of a film's projection a strain.

His first film, *Pussyfoot,* introduced the original cartoon cat. (Pat Sullivan's 'Felix the Cat' did not appear until the 1920s.) But despite its novelty, it was not a success. Veteran film maker George Pearson recalled in his autobiography that Louis Wain 'was quietly self-effacing, truly modest and honestly surprised by the demand for his work . . . but the strange technique was difficult for him, although he strove with painful slowness to produce the animation which he knew was essential.'

In 1917, Louis' eldest sister, Caroline, who made most of the family decisions, became a victim of the influenza epidemic of that year, contracted bronchial pneumonia and died. Her death affected Louis deeply. A year later came the end of the long war, and slowly the publishing trade began to revive. Wain obtained a

commission from Faulkner to illustrate *The Story of Tabbykin Town in School and Play*, and Valentine asked him to illustrate a series of books by Cecily M. Rutley. The result was five titles: *The Tale of Little Priscilla Purr*, *The Tale of Naughty Kitty Cat*, *The Tale of Peter Pusskin*, *The Tale of the Tabby Twins* and *Goody Cats Paws*. The next year, also for Valentine, he illustrated a series of 'Rocker' books (cut-out, pop-up books) which, when opened up, would make the characters rock to and fro with their eyes rolling.

He worked long hours and was persuaded to endorse Phospherine (a pick-me-up) in an advertisement, saying that thanks to the product 'I am now able to comfortably work more hours without the slightest detrimental effect.' There was a detrimental effect, but not caused by the Phospherine. Those who knew and cared for Louis Wain began to suspect that his mind was failing.

He had started correspondence with H.C. Brooke, the art editor of *Animals*, about the possible development and breeding of spotted cats. In the last *Louis Wain's Annual* of 1921, he introduced wallpaper and patterned fabric and carpet designs into the backgrounds of his cat drawings. Now the backgrounds took over and a new breed of patterned cats ran riot.

He spent a great deal of time writing. Sometimes the phrases were meaningless. At other times they give a glimpse into a world of fantasy vision, as in *The Cat's Rubáiyát*, published in the 1921 *Annual*: 'Who dared my cushion rare displace? Who my chair occupy? 'Twas in this mood I lived, and saw the light of magnificence. Rare plants gave a key of daintiness to the surroundings, and they, rich silks, brocades and satin clothes, carpets and rugs that came from afar, carved woods of rare

design – these, and pictures too, lent a glamour to my interest.'

Since Caroline's death in 1917, it had become increasingly difficult for his other sisters to manage him. Louis grew suspicious, accusing them of stealing his money and belongings. He started moving furniture around the house at all times, day and night, believing this would protect him from landlords and imaginary bailiffs. Finally, after pushing two of his sisters about and being found wrestling with a large picture, they called a doctor, who diagnosed him as suffering from dementia. Certified insane, Wain was taken in June 1924 to the paupers' ward of Springfield Hospital, Tooting, in south London, which housed the Surrey County Mental Asylum. He was 63 years old.

Here the diagnosis was schizophrenia. The records show that Wain reported having been 'bothered by spirits day and night for six years', which would date the start of his illness to the death of his sister, rather than – as his other sisters had suggested – from his fall from the bus in 1914. Despite his delusions, he settled down quite quickly at Springfield Hospital and soon started to draw and paint again, arousing the admiration of staff and visitors.

At home, his sisters sorted out his affairs as best they could. Josephine continued to run the household. Claire and Felicie gave sketching lessons and produced miniatures, decorated glass and fore-edge paintings on books. They visited Louis most weeks, taking him what treats they could afford, together with artists' materials. They in turn would collect any finished work and take it away to sell.

He had been at Springfield Hospital for just over a year, when the hospital guardians made one of their periodic visits. One of them was Dan Rider, the bookseller, who recalled noticing 'a

quiet little man drawing cats'. 'Good Lord, man', exclaimed Rider, 'you draw like Louis Wain.' 'I am Louis Wain', replied the patient. Astonished at his discovery, Rider approached G.K. Chesterton's sister-in-law, Mrs Cecil Chesterton, a well-known philanthropist, and an Appeal Committee was set up. The Louis Wain Fund was launched at the beginning of August 1925, and donors included Princess Alexandra, Lady Theresa Berwick, Sir Squire Bancroft and the author John Galsworthy. *The Times* reported the artist's plight, and the Chesterton appeal was printed in many papers in Britain, the United States and elsewhere. It dealt emotionally with what Louis Wain had done for animal welfare and how he now came to be in a mental hospital. On 17 August 1925, the *Daily Graphic* launched a 'Louis Wain Competition Week' and published readers' personal memories of the artist.

The following week the Prime Minister, Ramsay Macdonald, became personally involved, and in his appeal said that 'Louis Wain was on all our walls fifteen to twenty years ago. Probably no artist has given a greater number of young people pleasure than he has.' Another appeal was broadcast on the BBC by the actor Robert Lorraine. It had been written by H.G. Wells, who said that generations had been brought up on Louis Wain's cats, and few nurseries were without his pictures. 'He has made the cat his own, he invented a cat style, a cat society, a whole cat world. English cats that do not look and live like Louis Wain's cats are ashamed of themselves.'

As a result of the Prime Minister's personal intervention, Louis Wain was transferred to the Royal Bethlem Hospital ('Bedlam') in St George's Fields, Southwark. Wain had a room of his own in which he could keep his personal belongings. He soon settled in

and was quiet and co-operative. His old-fashioned manners, mode of speech and dress placed him firmly in the nineteenth rather than the twentieth century. A rediscovered celebrity, he enjoyed the status of an important patient.

In 1930 the Royal Bethlem Hospital moved to new buildings near Beckenham, in south London, where it is today. It was decided that Louis Wain should not go there, but be moved instead to the more rural environment of Napsbury, the County Mental Hospital near St Albans, with its spacious landscaped gardens. Disturbed by the upheaval, the 70-year-old artist found it difficult to settle down, but in time he began to enjoy the grounds, the birds and the animals. His drawings of this period often include idealized mock-Tudor buildings, based on the buildings in the hospital grounds and memories of 'Bendigo Lodge' at Westgate-on-Sea. They show that he had lost little of his technical skill, and his sisters continued to sell his drawings. But the market had started to grow away from him.

In Louis Wain's last years, although still working, he quickly showed signs of mental fatigue and his speech often became incoherent. At this time he produced what have been called 'psychotic' drawings, in which the cat has gradually disappeared into the design. Some of these have been preserved in the Guttmann-Maclay Collection at the Institute of Psychiatry in London. Eloquent testimonies to the development of his schizophrenia, they are also remarkable creations in their own right. At Napsbury, he continued the practice begun at Bethlem of painting on mirrors Christmas scenes with Santa Claus cats. Several of these mirrors are still kept at the two hospitals.

The last exhibition held during Louis Wain's lifetime took place in June 1937 at the Clarendon House Gallery in Clifford

Street, London. The *Daily Express* reported 'Artist in Asylum Paints On: Gives Exhibition'. Some 150 drawings were shown, priced from 10 shillings to £10. The critic noted that the drawings 'have all the old touch of fantasy'. *Everybody's Weekly* ran a rather tasteless article under the heading 'He laughed at cats – until they robbed him of wealth, health and reason'.

In November 1936 Wain suffered a stroke, and by May 1939 he had become almost totally incoherent and bedridden. He died on 4 July 1939, close to his 79th birthday, and was buried at St Mary's Cemetery, Kensal Green, alongside his father and his sisters Caroline and Josephine.

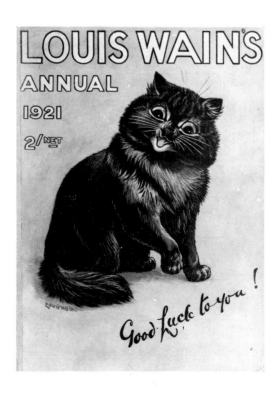

Sources of the Illustrations

The author would like to express his gratitude to Miss Denise Hooker for her help, to Mr Hugh Kelly for providing photographic material and to all those named below who supplied illustrations.

Dr Chris Beetles (private collection) 33, 46–47; Chris Beetles Ltd 2, 36–37, 38, 39, 45, 53, 56, 62, 69, 73, 79; Mr Henry Boxer 14, 15, 29, 51, 55, 58, 61; Christie's International Ltd, London 49; Philip Keane 41, 59; Mr Michael Parkin (private collection) jacket, 19, 21; Michael Parkin Fine Art Ltd 6, 9, 11, 20, 33, 40, 44, 48, 50, 52, 54, 57, 70, 71; private collection, London 12, 13, 17, 25, 27, 30, 34, 35, 43; Victoria and Albert Museum, London 7, 23, 28, 31.